Art as Far as the Eye Can See

Art as Far as the Eye Can See

Paul Virilio

Translated by Julie Rose

Oxford • New York

This work is published with the support of the French Ministry of Culture
– Centre National du Livre.

ïi institut français

This book is supported by the French Ministry for Foreign Affairs as part of the
Burgess Programme headed for the French Embassy in London by the Institut
Français du Royaume-Uni

First published in France, 2005, by Editions Galilée
© Galilée, 2005, L'art a perte de vue
English Translation © Berg Publishers, 2007

English edition
First published in 2007 by
Berg
Editorial offices:
First Floor, Angel Court, 81 St Clements Street, Oxford OX4 1AW, UK
175 Fifth Avenue, New York, NY 10010, USA

Berg is the imprint of Oxford International Publishers Ltd.

Library of Congress Cataloging-in-Publication data
Virilio, Paul.
 [Art à perte de vue. English]
 Art as far as the eye can see / Paul Virilio ; translated by
Julie Rose. — English ed.
 p. cm.
 Includes bibliographical references and index.
 ISBN-13: 978-1-84520-611-6 (cloth)
 ISBN-10: 1-84520-611-8 (cloth)
 1. Art, Modern—21st century—Philosophy. 2. Visual communication in
art. 3. Art and popular culture. I. Title.

 N6497.V5713 2007
 701'.03—dc22

 2007016322

British Library Cataloguing-in-Publication data
A catalogue record for this book is available from the British Library.

ISBN 978 1 84520 611 6

Typeset by JS Typesetting Limited, Porthcawl, Mid Glamorgan.
Printed in the United Kingdom by Biddles Ltd, King's Lynn.

www.bergpublishers.com

Contents

Acknowledgements

The translating of this work has been an exercise in 'the aesthetics of disappearance' of a painfully particular kind. The present published translation is a phoenix rising from the ashes of technological meltdown. If the bird doesn't fly as swiftly as it might, or its bite is not as sharp as the original, then we can safely blame 'the original accident' – and the translator. For their overwhelming support, I must thank some very wonderful people: my editor at Berg, Tristan Palmer, and the whole Berg team, Joanna Delorme at Galilée, and Paul Virilio, who is as generous a friend as he is constant and true.

A more personally painful disappearance occurred as I was completing the redraft in late December 2006. And I would like to offer up this

translation to Anita Joan Armfield, known to all as Nita, as well as to Esmé Ada Woodley and Marie Madeleine Rose, all three my cherished departed mothers.

To give that phoenix, Cleopatra, the last word: 'I am fire and air; my other elements I give to baser life.'

Julie Rose

1

Expect the Unexpected

The seventeenth century was the century of mathematics, the eighteenth, of the physical sciences, and the nineteenth, of biology. *The twentieth century is the century of fear.* You'll tell me that fear is not a science. But science has had a hand in it from the outset, since its latest theoretical advances have lead it to cancel itself out and since its practical improvements threaten the entire Earth with destruction. What's more, if fear in itself cannot be considered a science, there can be no doubt whatsoever that it is a technique.[1]

So wrote Albert Camus in 1948. I would add that, since that date, fear has become a dominant

1

culture, if not an *art* – an art contemporary with mutually assured destruction.

Since the eighteenth and nineteenth centuries, history has seen a mounting extremism (which Clausewitz studied in relation to war) but this escalation, which was to end in the balance of terror between East and West over the course of the twentieth century, has not been appreciated at its just value in relation to peace – to the peace created by deterrence that today subtends all mass media culture.

In fact, the postmodern period has seen a gradual drift away from an art once substantial, marked by architecture, music, sculpture and painting, and towards a purely accidental art that the crisis in international architecture flagged at practically the same time as the crisis in symphonic music.

This drift away from substantial art has been part and parcel of the boom in film and radio and, in particular, television, the medium that has ended up finally flattening all forms of representation, thanks to its abrupt use of presentation,

2

whereby real time definitely outclasses the real space of major artworks, whether of literature or the visual arts.

If, according to Hegel, 'philosophy is an era put into ideas', we have to concede that the idée fixe of the twentieth century has been the acceleration of reality and not just of history.

We have seen what speed did to politics yesterday with Futurism, fascism and the turbo-capitalism of the Single Market. What we are seeing now, especially, is what speed does to mass culture, since, if 'time is money', the speed of the light of the ubiquitous media means the power to move the enthralled hordes.

Having reached this point, at the very beginning of the twenty-first century, the most important political issue we face is not the Cold War and its forgotten collapse anymore, but the emergence of this cold panic of which terrorism, in all its forms, is only ever one symptom among others.

Comparable to uncontrollable terror, panic is accordingly irrational and its so often collective

nature clearly indicates its propensity to turn, virtually any day, into a total social event.

Indeed, through their (often programmed) repetition, a population's disturbing panic attacks are associated with a depression often masked by the routines of everyday life. What I call 'cold panic' is thereby linked to this expectation horizon of collective anguish, in which we strive to expect the unexpected in a state of neurosis that saps all intersubjective vitality and leads to a deadly state of CIVIL DETERRENCE that is the lamentable counterpart to MILITARY DETERRENCE between nations.

'To obey with your eyes shut is the onset of panic', Maurice Merleau-Ponty had already observed in 1953. 'In this world where denial and morose passions take the place of certainties, people seek above all not to see.'[2]

Coming from the phenomenologist of perception, this observation took on significance as a warning in a period of history that deliberately engaged in a lapse of attention which lasted not for a minute but for a whole century.

4

With 'teleobjectivity', our eyes are thus not shut by the cathode screen alone; more than anything else we now no longer seek to see, to look around us, not even in front of us, but exclusively beyond the horizon of objective appearances. It is this fatal inattention that provokes expectation of the unexpected – a paradoxical expectation, composed at once of covetousness and anxiety, which our philosopher of the visible and the invisible called PANIC.

But this composite word covers another term contemporary with the historic period of Merleau-Ponty's inaugural discourse: DETERRENCE.

If the twentieth century is the century of fear, it is also the century of atomic deterrence, which, during the years from 1950 to 1960, established the technique of 'the balance of terror' and moved Albert Camus further to say: 'The long dialogue between men has just ceased. A man who can't be persuaded is a frightened man.'[3]

Extending this obvious fact, the man who was to receive the Nobel Prize for literature continued:

This is how *an immense conspiracy of silence* spread among people who already did not talk because they found it pointless, and it continues to spread, accepted by those who tremble in fear but find good reasons to hide this trembling from themselves, and encouraged by those who stand to gain from it. *'You must not talk about the purge of artists in Russia because that would benefit the reactionaries'* ... I said fear was a technique.[4]

And this is how, midway through a pitiless century, the technique of panic lead to the art of deterrence – not only strategic deterrence between East and West in a world threatened with extinction, but also political and cultural deterrence. This 'world in which denial and morose passions take the place of certainties', which certain self-righteous conformists, chiming in with Sartre, were to call 'engagement' or 'commitment'. The world of contemporary art, which was soon to drift, in turn, from 'social realism' towards 'pop culture' and the realism of an art market that still dominates these early years of the twenty-first century.

Basically, it all began when painters relinquished the study of the subject and went back inside their studios in a re-run of the age of academic classicism.

With Impressionism or, more exactly, after the Great War, modern art was dragged down into the panic that struck Expressionist Europe and saw the emergence of Surrealism, hot on the heels of Dadaism. We can extend this foretaste of disaster, furthermore, to European philosophy, with the discrediting of phenomenology, the disappearance of Husserl and the resounding success of Existentialism, in that period of transition that kicked off between the two world wars and found its consecration in the 1950s just evoked, with the end of the dialogue between men and, especially, with forgetting: that loss of empathy not only in relation to others, but in relation to a human environment turned into a desert through the annihilation brought about by the air raids that, from Guernica to Hiroshima, via Coventry, Dresden and Nagasaki, have blurred our view of the world, that perception DE VISU –

with our own eyes – which subtended the whole of Western culture for 2,000 years.

But, apart from the 'aeropolitics' of a mass extermination of cities, which was to put paid to continental geopolitics – the retinal detachment of a culture that already anticipated the economic deterritorialization of internationalization – we should also note how, from the nineteenth century on, the progress in popular astronomy so dear to Camille Flammarion ushered in the sudden multiplication of the telescopes that were to foreshadow the shift in viewpoint occasioned by the boom in domestic television, itself favoured, over the twentieth century, by the launch of telecommunication satellites.

To see without going there to see. To perceive without really being there... All this was to shatter the whole set of the different phenomena involved in visual and theatrical representation, right up to representative democracy, itself threatened by the broadcasting tools that were to shape the standardized democracy of

public opinion as a prelude to landing us in the synchronized democracy of public emotion that was to ruin the fragile balance of societies supposedly emancipated from real presence.

In a world based on denial and general deterrence, where one now seeks less to see than to be seen by all at the same instant, whenever we refer to transhorizon 'Large-Scale Optics', we immediately invoke transpolitical 'Large-Scale Panic' in the face of the acceleration of a common reality that not only outstrips us in tyrannical fashion, but literally outpaces all objective evaluation and thereby all understanding.

A morgue assistant named Maurizio Cattelan, who calls himself 'an accidental artist', once declared: 'I handled dead people and I saw their distance, their impenetrable deafness. A lot of what I've done since then comes from that distance.'[5]

After the issue of instantaneity's lack of delay, here we have the issue of ubiquity's distance, only the perspective is reversed: what now counts

is not the vanishing point in the real space of a scene or a landscape, but only vanishing in the face of death and its question mark – its interrogation point – in a perspective of real time used and abused by the cathode screen with live broadcasting, offering 'death live' and an endless funeral procession of repeat disasters.

So, after abstraction, the monochromatism of, say, Yves Klein and the advent of an imageless painting,[6] when nothing more can get to us, really touch us, you no longer expect some brainwave of genius, the surprise of originality, but merely the accident, the catastrophe of finality. Whence the secret influence of terrorism, following on from (German) Expressionism or (Viennese) Actionism, as though Jerome Bosch and Goya endorsed the debauchery of crime.

Note, on this score, that the furiously contested show staged at the beginning of the year 2005 in the Kunst-Werke, Berlin's Institute of Contemporary Art, with the title 'Regarding Terror: The RAF. Exhibition', based its underlying concept, which was aimed at denouncing the

so-called myth of the Rote Armee Fraktion, the Red Army Faction (RAF), on the works of three generations of artists, including Joseph Beuys, Sigmar Polke, Gerhard Richter, Martin Klippen Berger and Hans Peter Feldman, whose danse macabre aligns the names, faces and bodies of terrorists, but also of their victims, in a strange process that singularly recalls the looping of televised sequences.

In fact, the 'redemptive suffering' of contemporary art arises from profanation not of the sacred art of our origins anymore but of the profane art of modernity, that (critical) moment when re-presentation gives way to the lyrical illusion of presentation, pure and simple. When 'art for art's sake' bows down before the TOTAL ART of multi-media teleobjectivity that takes over from the artifices of the seventh (cinematographic) art, which already claimed to contain all six others.

This is it, the obscenity of ubiquity whereby 'postmodern' academicism outdoes all the avant-gardes put together, with the exception of the

particular avant-garde of mass terrorism, whose advent the television series brings to the light of day, in the place and space of the action of antique tragedy.

Here a parallel suggests itself between the atheism of postmodernity that sets out 'to replace what it destroys and begins by destroying what it replaces',[7] in a sort of lay deicide, and the atheism of the profanation of modern art to the exclusive advantage of a cult of replacement that has all the characteristics of illuminism – not the illuminism of the encyclopaedic revolution of the Enlightenment now, but the illuminism of a multi-media revelation that exterminates all representative reflection in favour of a panic reflex on the part of an individual whose relativism (ethical and aesthetic) suddenly disappears in the face of this virtualism that acts as a surrogate for the actual world of facts and established events.

If, today, theologians talk about an 'atheism that even strives to do away with the problem that caused God to be born in our consciences in

the first place',[8] critics of contemporary art toss around the notion of an 'anthropotheism' that would even do away with the origins of modern art, of its free expression, which is no longer figurative now as once upon a time but graphic and pictorial (whence the iconoclastic ban on paintings in a number of art galleries).

At the end of the last century, Karol Wojtyla, better known as Pope John Paul II, declared: 'The problem for the Universal Church is knowing how to make itself visible.' At the start of the third millennium, this is the problem of all representation.

'We are everywhere you look. All the time and everywhere in the world.' This advertising slogan of Corbis, the agency founded in 1989 by Bill Gates with the avowed aim of monopolizing the photographic image, illustrates the large-scale panic that has beset representation in the age of scopic expansion.

If, for some, the aim is thus to see everything and also to have everything, for the anonymous hordes it is solely to be seen.

13

When you know that the Internet image provider brings together the photographic archives of the world's most prestigious museums, you can get some idea how important their real-time presentation now is and how much they discreetly discredit the works themselves – the real ones!

What was still only on the drawing board with the industrial reproduction of images analysed by Walter Benjamin, literally explodes with the 'Large-Scale Optics' of cameras on the Internet, since telesurveillance extends to telesurveillance of art.

Faced with this acceleration of reality, the new telescope no longer so much observes the expansion of the universe – the Big Bang and its distant nebulae – as the down-to-earth break-up of the sphere of perceptible appearances that are disclosed in the very instant of looking.

This is it, the multimedia REVELATION that surpasses the encyclopaedic REVOLUTION of the Enlightenment; this is it, the 'illuminism' of telecommunications that suppresses the pictorial

icon – but also the crucial importance of the glimpse de visu and in situ, to the exclusive advantage of live coverage of the perceptive field.

'In a digitized world, we offer creative visual solutions. The objective for us is to give a message the strongest impact',[9] says Steve Davis, the president and CEO of Corbis.

From this, we can more easily see through the recourse of visual/audiovisual creation to the looping of panic-inducing segments of terrorism or of natural or industrial disasters – this replay that television stations now systematically abuse, this combat sport that does battle with the apathy of televiewers who expect the unexpected alone to wake them out of their lethargy a little, out of the attention deficit that has replaced vigilance in them and, especially, all practical interest in whatever crops up in their immediate proximity. How can we be astonished or ultimately even scandalized by aggressiveness, by a violence that has now become customary at every level of society, when empathy, the twin sister of

15

sympathy for others, has disappeared from view at the same time as the phenomenology of which it was the heavy crux?

Too impressionist, no doubt, not actionist enough, perhaps? Once empathy goes, the 'reality show' replaces dance and theatre.

In the beginning, the term 'empathy' had the primary sense of 'touching' and referred to physical contact with tangible objects. With Edmund Husserl, it would come to denote the effort to perceive and seize the reality that surrounds us in all its phenomena, in all the forms in which that reality manifests itself. Whence the importance, at the beginning of the twentieth century, of Wilhelm Worringer's key work: Abstraktion und Einfühling (1907), translated as Abstraction and Empathy: A Contribution to the Psychology of Style.

We can apprehend to what extent tele-objectivity has today made us lose our grip, the immediate tact and contact that not only promoted the customary civility but also all actual 'civilization', thereby enhancing the impact of

a growing terror – this terror that can strike us dumb every bit as much as blind. A survivor of the 1943 bombing of Hamburg acknowledged its effects: 'It was my initiation into the knowledge that looking means suffering; so after that, I could no more stand looking than being looked at.'[10]

This is it, this eyes-wide-shut panic signalled by Merleau-Ponty at the start of the age of Large-Scale Deterrence!

But at the very start of the new millennium where the performance of instantaneous communication outclasses the substance of the oeuvre, of each and every oeuvre – pictorial, theatrical, musical – and where the analogy disappears in the face of the feats of digitization, Large-Scale Panic is panic induced by an art contemporary with the disaster in performances, the misdeeds of a telescopic perception where the instrumental image drives away our last mental images, one after the other.

Merleau-Ponty further wrote: 'Nature is an enigmatic object, an object that is not absolutely

an object; it is not absolutely in front of us. It is our ground, not what is in front of us, but what bears us.'[11]

By dint of looking in front of us, at eye level, we have ended up inventing the accident of the telescope, of all the telescopes, from Galileo's glass to the widespread telesurveillance that now exiles us beyond appearances in the trans-appearance of a far away that eliminates the near – whether it be the nearby tangible object or a nearby painting, even a self-portrait of one's fellow, one's like, favouring instead the plausible, the likely, and its virtuality.

Today we have no option, not to shut our eyes, but to lower them – not out of timidity but, on the contrary, out of courage in order to look steadily, not at the End of History, but at this 'support-surface' whose down-to-earth limit is visibly below us, in the HUMUS of a statics that has borne us from the beginning of time.

'The Earth does not move', warned Edmund Husserl at the end of his life. This is it, this reversal

of viewpoint of Galilean space: this ground, this floor of the great vehicle formed by a star that can no longer bear the acceleration of the real and so pits its fixity and its telluric resistance against the vanishing point of a horizon from now on doubly buckled.

This phenomenological paradox partly explains the recent geopolitical and strategic upheavals, but every bit as much, it would seem, those involved in the 'reality show' of an art contemporary with the foreclosure of the planet. There is a sort of return here of what was trampled and buried underfoot! Not the return to the Mother Earth of our pantheist origins but the return of an earthling's empathy with the enigmatic object our philosopher of perception so rightly talked about in relation to a Nature that not only surrounds us on all sides but has so long inhabited us.

'I am not moving around. Whether I am sitting still or walking, my flesh is the centre and I am grounded on ground that does not move', wrote Husserl. He concluded: 'For as long as the Earth

itself is actually a ground and not "a body", the original ark, EARTH, does not move.'[12]

However, the question of its (spatio-temporal) finiteness changes the nature of the original ground, since the end of extension poses in return the question of its fixity, of its inertia in relation to the world of the living who are moving around on the spot.

Not long ago my flesh as an earthling seemed, indeed, to be the unique centre of the living present Husserl is talking about, but since the acceleration of reality in the age of temporal compression, this carnal centre of presence extends to the TELEPRESENCE in the real-time world delivered by the instantaneity of a ubiquity that has now gone global.

Here, the 'dromoscopy' – the optical illusion experienced by the motorist whereby what stays still appears to recede while the interior of the moving vehicle appears stationary – taints representation of the whole world, not just the roadside.

We suddenly jump from real-space object-
ivity de visu and in situ to the real-time tele-
objectivity of an acceleration whereby the spaces
of perception, the optical space and the haptic
space of the tangible, undergo a disturbance – a
topological or, more precisely, a TOPOSCOPICAL
disaster.

What illusion are we actually talking about
when one's body proper is identified with the
world proper? And, in particular, what is the
impact on the egocentricity involved in this
MEGALOMANIA that has struck not just a few
disturbed individuals but the whole of the living
gathered in front of their screens?

Within this logic of the great lockdown, where
inside and outside merge, the world is not only
the gigantic phantom limb of humanity, but
also means hypertrophy of the ego, a sort of
INTROPATHY that then takes over from mutual
SYMPATHY.

We might recall what Maurice Blanchot had
to say on the carceral policy of the eighteenth

century: 'To shut up the outside, to set it up as an expected or exceptional interiority, such is the requirement that needs to be in place for madness to be made to exist – meaning, for it to be made visible.'[13]

What can we say of INTROPATHY, at this early stage of the twenty-first century, except that it makes visible the general spread of the megalomania involved in real time along with its inertia?

'Is there a privileged Here? Yes, absolute zero energy', Husserl announced in 1934.

'Seeing that it is the most comfortable, the reclining position ought to be the zero position', the German phenomenonologist concluded, thereby introducing, after the seated woman, the age of reclining man.

So this is it, this finiteness of the 'action quantum' whereby the inertia of the star that bears us becomes the inertia of the animated being – that political animal whose vitality, once celebrated by the Greeks, today buckles before the comfort of zero energy in a man who is not

even a true spectator any more, but the author of a domestic virtuality on a life-size scale.

Paraphrasing Karl Kraus on the subject of PSYCHOANALYSIS, only this time apropos the TOPO-ANALYSIS of globalization, we could say that it is the symptom of a disease that claims to be its own therapy!

'I, the horizon, will fight for victory for I am the invisible that cannot disappear. I am the ocean wave. Open the sluice gates so I can rush in and overrun everything!'[14] For those of us who live in the twenty-first century, Apollinaire's prophecy came to pass a long time ago already.

Since the wave of electromagnetic fields flooded the earth with audiovisuality, not only has the skyline been locked down in the rectangle of the screen, of all the screens, but the spectator has now morphed into a televiewer who stretches out or, rather, lies down in front of it.

In bygone days, they used to describe painting and the picture that resulted as an 'open window'... What remains of this optical metaphor?

For instance, what is the teletopology of a building under telesurveillance in which, from each abode, you can watch all the others; in which, more precisely, each of the rooms of the sundry apartments functions like a video control unit, monitoring the whole set of the others?

Even more crucially, what teleobjective worldliness are we dealing with when the same thing goes for each of the five continents, for the towns that people them and for their innumerable buildings covered in antennae?

If, according to Plato, the sophism of the painter consisted in only showing his 'mirage' at a distance, what mirage are we dealing with today, with the real-time televising of the world?

Having worked in the past with a number of painters and stained glass makers, I always felt that the Gothic opening of the great rose windows of cathedrals was less an opening on the sky than an opening on the light of the beyond up above. With the trans-appearance produced

by electromagnetism, teleobjective illuminism, on the other hand, no longer opens on anything but the here below.

Miserable miracle of a MEGALOSCOPY whereby the latest telescopes are no longer turned on the night sky now but on the satellite belt, the endless day of 'real time'.

Here, the EGOCENTRICITY of the human being's body proper is transferred to the inertia of the earthling's world proper – in other words, to peripheral EXOCENTRICITY – for this man of the Last Day who is now no more than a fully fledged sedentary being, a lounge lizard, driven by his megalomania to revise more than to revisit his cramped domain, in an ambulatory dementia in which accelerated displacement doesn't even mean a journey any more, but a vibration analogous to that of the waves that convey his telescopic sensations...

To wrap up these comments, we might now observe that if the discovery of the (animated) cinematographic image was indeed contemporary with the first great wave of transatlantic

migration, since that time the transport revolution has gone supersonic and the (televisual) videographic image has reached its peak shortly after aeronautics reached and broke the sound barrier.

Once that happened, thanks to supersonic rocket propulsion, it was no longer the heat barrier that was broken. The light barrier had become the ultimate objective of our view of the world.

In this sudden transmutation of aesthetics, we can better glimpse the reasons for iconoclasm, the programmed demise of the fixed image offered by paintings now banned from being hung, and the infatuation of art for art's sake with performance, along with all the installations of every stripe that systematically clutter gallery and museum spaces. Similarly, we can better understand the persistence of a kind of sculpture whose inertia and statics have become emblematic of this sedentary being, a lounge lizard, this universal bedridden invalid, contemporary with the MEGALOSCOPIC age. We can also understand the historical importance of land art when, in

the twentieth century, landscape is displayed on film, in the freeze frame – a photo-finish in which the photographic shot is now scarcely more than the proximity of a frozen sequence: that of instantaneity.

As in the panic evoked above, with the photographic sequence looking means suffering the irremediable, the dread involved in a fixation whose inertia is illustrated even more clearly by the looping of televised sequences. This is not just the inertia of the fixed image of bygone days, but that of the animated image, looped back on itself, as was the revolving stage of the panoramas of yore, as is the MEGALOSCOPY of the parabolic antennae of today, hooked up as they are to the endlessly revolving broadcast satellites of 'world vision'...

Strangely, cutting-edge aeronautics has taken the same turn, since certain prototypes, like Voyager not so long ago or Global Flyer today, seem bent on turning into low-orbit satellites, performing round-the-world flights with no stops and with no refuelling.

Figures of a tourist itineracy in the end as derisory as that involved in the postural inertia of reclining man, riveted to his screens, or that of those traders in quest of surplus values whose supplies of capital whiz round the Earth several times in the one day before filling the coffers of the stock-exchange casino.

Fatal signs of a planetary foreclosure, these new fairground merry-go-rounds could well bring out a boredom of the third kind, that close encounter involving contact, following the boredom induced by close encounter with the television series: no longer the boredom once produced by uniformity but the boredom that will be produced tomorrow by circularity (circum terrestre).

'Escape for thy life, look not behind thee, neither stay thou in all the plain!' warned the emissary from Heaven. But Lot's wife 'looked back from behind him and she became a pillar of salt'.[15]

A Biblical symbol, the tale of the annihilation of Sodom emphasizes, at one and the same

time, the turning away from morals and the turning back of the observer of the disaster. Something analogous is at work today, it would seem, before our very eyes, in this turning to ice whereby accelerated cathode reality results in a trans-appearance that not only penetrates the horizon of perceptible appearances but the flesh of denuded bodies or, further still, those materials whose opacity once obstructed the eyes' cupidity.

Whether the philosopher of the eternal return, Nietzsche, likes it or not, it is no longer the growth of the desert that awaits us, but its impassability, its turning into a closed circuit. Characteristic of this celestial closure is the land art of James Turrell, pilot emeritus whose tourist plane became a studio, a flying studio, not unlike the folding easel Van Gogh took with him on the road to Arles, and which has served him 'to return to the subject', in Desert Paints, exploring a habitable crater...

But, to conclude, let's get back to that specific panic evoked by our philosopher of perception

in 1953. At the Poitiers Futuroscope theme park, in 2005, a new attraction was launched. It was called: 'Eyes Wide Shut'.

And so, half a century after Merleau-Ponty's caution, futurism has abruptly transformed itself, for, at the Poitiers site, the experience proposed is no longer bound up with new image technologies, as in the recent past. It is an experience of voluntary blindness.

In a light-proof building, visitors gather in groups of ten for a guided tour led by one of the sightless; as in Breughel's painting, The Blindman and the Paralytic, everyone has to hang on to the shoulder of the person in front. During this initiatory trip into the heart of darkness the visitor passes through three different ambiences in succession: swamp, city, beach. As for the guide's message, it goes like this: 'Don't hesitate to touch!' ... thereby indicating to all and sundry that for them, from now on, sight and touch are the same thing. As one of the officials in charge of the Poitiers image park puts it: 'By coming here, people give themselves a challenge, for in

this course roles are reversed, social barriers drop and you get a better understanding of what blind people feel.'[16]

TELESCOPE, MICROSCOPE, FUTUROSCOPE, Galileo's long sight results in the blindness involved in a bout of role-playing in which everyone carries a handicap.

They don't want to see, they want to be seen, we wrote previously. By way of confirmation of this reversal of perspective provoked by cathodic teleobjectivity, note that the FUTUROSCOPE will also open a second 'flagship attraction', called 'Stars of the Future', with the aim of showing the ambience on the set during a television shoot to visitors suddenly transformed into actors, alongside real actors, people working in the performing arts, who will help give them a taste of the joys and the sensations of telereality.

Notes

1. Albert Camus, *Actuelles. Ecrits politiques* (Paris: Gallimard, 1950). English edition

Camus at Combat: Writing 1944–1947 (Princeton NJ: Princeton University Press, 2005), ed. Jacqueline Lévi-Valensi, tr. Arthur Goldhammer (translation modified).

2. Maurice Merleau-Ponty, *Eloge de la philosophie* (Paris: Gallimard, 1953).
3. Camus, op. cit. Camus actually says 'a frightening man' (translator's note).
4. Camus, op. cit.
5. *Courrier international*, February 2005.
6. Cf. Patrick Vauday, *La Peinture de l'image* (Pleins Feux, 2002).
7. Merleau-Ponty, op. cit.
8. Ibid.
9. Advertising copy, 2005.
10. Hans Erich Nossack, Nekyia, *Récit d'un survivant* (Paris: Gallimard, 1955), French tr. D. Naville.
11. Merleau-Ponty, op. cit.
12. Edmund Husserl, *La terre ne se meurt pas* (Paris: Minuit, 1989).
13. Maurice Blanchot, *L'Entretien infini* (Paris: Gallimard, 1969).

14. Guillaume Apollinaire, *Tendre comme le souvenir* (Paris: Gallimard, 2005).
15. Genesis XIX, 17:26.
16. 'La vue par le toucher' in *Sud ouest,* 24 April 2005.

2

An Exorbitant Art

Has aeronautics become an aesthetics and aviation an art, as Santos-Dumont hoped? Certainly not, but it has most definitely become a performance, a feat of levitation Leonardo da Vinci long dreamed of.

In the beginning, the aeroplane was not just one means of transport among others, but an observation tool for seeing the surface of the world from on high; an altimetric distancing device designed to dominate the Earth at a single glance, and the surest means, after the tower, of seeing not only from a long way away, as with longsightedness or the telescope, but from high up.

On this subject, let's hear it from painter-cum-writer, Marek Halter: 'Pollock understood that

America was not just an extension of Europe, that America was vast and that this ought to be felt in painting.' Struck by this height in vantage point, which had less to do with pictorial technique than with the new-fangled aeronautical technology of the Wright Brothers, Halter goes on: 'Pollock is the first painter to abandon the easel and place the canvas on the ground in order to take in the painting from above. It's like a landscape seen from a plane. European paintings are landscapes seen from the window of a train.'[1]

You notice how, here, the vehicle is the determining factor in distinguishing the avant-garde nature of the art of painting: the train and its (dromosopic) cinematics, the aeroplane and its (altimetric) statics.

For the Old Continent, the outlook is on the horizon and its railroad perspective; for the New World, the outlook is on the NADIR starting from the aerial zenith – that abstract world of aeroscopy celebrated by Nadar that, at the close of the twentieth century, would end in the televisual MEGALOSCOPY referred to above.

36

But, here, the artistic achievement of Jackson Pollock and a whole host of others, is a scopic turning back to face the terrestrial surface. Instead of observing the line that decides between Earth and sky, you observe the surface, the 'support-surface', as people once contemplated the stars in the age of popular astronomy. This has reached the point where the AERODROME of teledetection by observation satellite will soon prevail over the gaze turned on infinity of an ASTRONOMY on which the whole panoply of our civilizations once depended, though.[2]

If we are to believe Marek Halter, the SUR-VISUALISM of abstraction took over – in the United States, at least – from the SUR-REALISM of the Old Continent, as a prelude to the in-continent TELEVISUALISM of a world buckled in on itself, in this 'real-time perspective' of ubiquity that gives the real-space perspective of the Quattrocentro its stereoscopic 'relief'.

This is it, the doping whereby artistic activity, like economic activity, bites the dust wherever excess wins out over the essay and wherever

the sporting absurdity of some record or other takes over from the experiment of genius. After Amerigo Vespucci's Italy, America, like Africa, was off to a bad start or, more precisely, it fell from a great height, for it is no longer a matter of some renaissance, but of a brutal return to Earth, to Earth's plenary substance...

Here, the accident in art, like the accident in a science devoid of a conscience, is its very success, its ex-centric prowess that drives it to insignificance.

And so the art for art's sake of a disunited Europe was overtaken, in the immediate post-war years, by the performance for performance's sake of American DRIPPING PAINT (Action Painting) à la Pollock, anticipating, for the end of the century, the eternal return of an orbital circulation whereby aero- and astro-nautics were to merge in a 'mannerism' that no longer speaks its name.

To fly or to overfly? To swim or to float? To live or to survive? Mermoz rejected the last option when he declared, just before disappearing: 'I wouldn't want to be a survivor.'

Yet that is the fate of an art contemporary with the aesthetics of (geospherical) finiteness where the progress of exhibitionism is too often pegged to the requirements of the market, with its competitive practices that have nothing to do with the advancement of knowledge, but solely with that of a closed-circuit parlour game where the spectacle of the unexpected has supplanted the spectacle of 'beauty'.

To stay in the realm of sport, we might take the example of the famous ocean liner, the Titanic, which sank on a certain night in 1912 not so much because of a navigation error, as has been claimed, but indeed because its course via the North Atlantic was supposed to allow it to win the 'Blue Ribbon' and so compelled it, despite the lack of visibility, to go full steam ahead at any cost.

According to White Star, the company that owned it, the ship did not swim; it floated before sinking without a trace. The titanic ocean liner did not pass via the North Atlantic; above all, it had to surpass its rivals from the Cunard Line.

The fatal accident of the shipwreck was thus not so much that of a supposedly 'unsinkable' ship as an accident in a competitive performance where the progress of excess speed no longer had anything in common with the progress of the in-flight test of pioneers like Montgolfier in aerostation or the Wrights in aeronautics.

After the ship, let's take the example of the aeroplane, also described as 'heavier than air'; to be more precise, let's take the example of Alberto Santos-Dumont's plane, DEMOISELLE.

Gazing at this plane some little time ago at an exhibition on the Champs-Elysées, it was all too obvious that this flying art object was indeed destined to fly, along the lines of the blue dragonfly it was named after, whereas the supersonic fighter planes and other supersonic 'combat jets' that surrounded it were destined to over-fly, to punch through the depths of the heavens, their performance as piloted missiles outdoing aeronautics, just as that of the ocean liner, the Titanic, tried to outdistance the nautical dimension of its transatlantic crossing.

'You can't stop progress...', they say. Sure, but what progress? The progress in the substance of the motor or the progress in the accident in its performance? A sporting performance whose reward is, if not a ribbon, then a medal, but more especially the operating earnings, a profit, that result from the doping of these arts et métiers that once practised experimental research – not the extreme sports of technoscience.

Synonymous with overkill, technological progress more than ever poses the question of reasoned choice between qualitative and quantitative.

To stay in the area that concerns us, note that since aviation turned, if not into an 'art' then at least into a 'dominant culture' with the orbital aeropolitics of globalization, the launch of the Concorde has been followed by the launch of the Airbus 380, the biggest airliner ever built, unveiled in an epic ceremony entitled 'REVEAL', which brought four European heads of state – British Prime Minister Tony Blair, French Prime Minister Jacques Chirac, German Chancellor Gerhard

Schröder and Spanish Prime Minister Jose Luis Rodriguez Zapatero – together in Toulouse at the Jean-Luc Lagardère Final Assembly Line, on 18 January 2005.

After the case argued for supersonic and shortly hypersonic speed, according to the words of the prophets of a happiness suspended from the pods of reactors, comes the case argued for the maximum carrying capacity of a 'superjumbo' jet capable of carrying over 800 passengers. Here again, what progress are we talking about if not progress in purely quantitative excess?

Along the lines of Boeing's Jumbo jet, the Airbus will not exceed the hypersonic limits initially provided for the Concorde's successor; it will merely put in the air, at the same time, in one and the same aircraft, close to a thousand people...

If this is real progress in the transcontinental aeroplane, it is also progress in the major risk of causing a whole mass of passengers to perish, swiftly, in one and the same crash.

Is the goal of civil aeronautics, in fact, to put everyone in the air, as the advocates of the FLYING NATION of the totalitarian regimes of the 1930s already hoped to do?[3]

Are we dealing with some kind of economic progress that would facilitate the democratization of air transport, a progress necessarily shared by all, at the same time, as a slogan of the SNCF, France's national railway company, claims?

Let's nudge technoscientific outrageousness along: if tomorrow or the day after, they once more send up gigantic dirigible balloons capable of carrying thousands of passengers at reduced fares, which it seems is on the cards, will this be about the future of aeronautics or its past?

Aware of the obesity of the 'superjumbo', humorists at the Toulouse shindig noted that all that was missing was a swimming pool and a tennis court... But let's be serious! If the fact of navigating the seas and oceans represented certain progress for the earthlings that we are, if flying over the top of the clouds meant even

greater progress, the excess involved in the performance of this new type of displacement has nothing whatever to do with progress because the Earth is a limit not only due to its reduced size but also due to its composite telluric nature.

Two kinds of accident confront us today: the accident in the essay, the test, one that happens in the discovery of a substance, noxious or otherwise, or the invention of some technical object or other, useful or otherwise; and the accident in excess of all kinds – the sporting, not to say, Olympic, quest for record results at any cost, including the lives of innocent victims.

These expressionist practices are linked to the doping of the 'top level' champion, in which the progress in excess is merely a mass killing analogous, in the end, to the desperate quest for 'mutual destruction' on the part of military men of all stripes. In these conditions, the extreme sport of technoscientific progress would scarcely amount to anything more than an agreed human sacrifice, at least for some time to come yet.

Born the same year as the Lumière Brothers' cinematograph, aviation has little by little turned into a sort of large-scale circus where the breaking of the famous sound barrier foreshadowed the propulsion that was to allow rockets shortly after to exceed escape velocity, thereby anticipating the 'illuminism' of a large-scale televisual optics that, for its part, would put to work the speed of light.

After Alberto Santos-Dumont, aviation's poet, and Charles Lindburgh, its trans-Atlantic prophet, we have the American engineer, Burt Rutan, who is now leading the race around the world with his Global Flyer, which, as it happens, has just 'looped the loop' in under 80 hours – 67 hours, to be precise – something Jules Verne would never in his wildest dreams have hoped to achieve.

Walk One for a single man, in the event Steve Fosset, unbeatable all-round champion of a CIRCUM TERRESTRIAL DERBY, who executes his closed circuit in the manner of a thoroughbred on

the hippodrome, thereby transforming the low orbit of his manned flight into a HOMODROME.

To conquer at any cost the reserve of resistance to advancement: that offered by the too-long duration of distances (aerostatics) every bit as much as by the toughness of materials (their statics), that's what it's all about! From now on, that is the objective of the all-out record achievements of the excess in progress.

After astronomic telescopy and televisual videoscopy, the aeroscopy of our view of the world has tipped the gaze of each and every one of us inwards towards the centre of the Earth, while we wait for the unending round of spy satellites in turn to exercise the navel-gazing we are now so familiar with, in practising the most extreme police telesurveillance.

And so, the extraverted perspective of real space, which was the perspective of the art of painting of the Quattrocento, has been overtaken by the introverted perspective of this real time that provokes the 'relief' of the occurrence of the world. But this relief lacks a third dimension

and owes everything to the fourth dimension and to the intermediary of the instantaneity of telecommunications.

After the highs and lows of stereophonic high fidelity, the time is now upon us of a stereoscopy in which the actual and the virtual replace left as well as right, high as well as low...

Faced with this sudden disorientation, how can we still be amazed at the profanation not only of art, but also of a politics of nations that advertising has thoroughly exploited, leaving its traces, as it has done, from Magritte right up to Warhol and Saatchi, to say nothing of the role of the spin doctor, that complicit and all-too-often complacent agent in the governing of a world from now on FORECLOSED...

Whereas the 'sacred art' of humanity's origins devoted itself to painting the hereafter – whence its close association with astronomy and astrology – the profaned art of the present (telepresent) time is only interested in the here-below through 'entropathical' gesticulations and contortions that demonstrate not so much its vitality as its

47

inertia. We no longer expect anything now from art lovers turned 'art consumers' other than their passivity, their conformism. At least then we can surprise them, shake them up a bit with a spectacle that is less alive than dead-alive, in the hope of causing their reserve of resistance to boredom to crumble due to the accident of something unforeseen that tends to compensate for vision the way the unexpected suppresses expectation.

Now, after the arts of the 'modern movement' (theatre, dance, the circus, aerobatics...) let's move on to the arts of fixity and statics, such as sculpture, which we've talked about in relation to the inner statue of the latest sedentary human being; let's move on, then, to architecture and the resistance of the materials it uses.

A recent event, the publication of the Berthier Report, the findings of the official inquiry into the collapse, in May 2004, of Roissy Airport TERMINAL 2E in Paris, illustrates the vexed question of the too low intrinsic fatigue resistance of that building's structure.

Here again we touch on the question of the SUBSTANCE of a material (concrete) and its overall (architectonic) PERFORMANCE. Now, what is at issue here is no longer the author (the architect), or this or that precautionary principle rigorously monitored by experts, but once again the progress in excess.

In fact, what is at issue in the airport terminal's use of a concrete shell is the reserve of resistance of the load-bearing structure employed, which was gradually reduced and weakened before being cancelled out completely in a relatively short space of time.

But what are they referring to, exactly, when they talk about intrinsic fatigue resistance?

What they are referring to is the architectonic precaution that not only assures the stability of the edifice but also its durability, following the example of a long-distant past (the Roman era, for instance), where the mechanical redundancy of building elements was, if not completely un-warranted, then at least excessive.

Today, the opposite happens. The thickness of the elements implemented is reduced to next to nothing in the name of a prowess not so much architectural as structural. In this case, as it happens, we are talking about the thickness of the concrete shells of the Roissy terminal. And not so long ago, it was a matter of the thickness of the CNIT dome in Paris' La Défense quartier. It is still a concern the whole world over, wherever you find wide-span roof coverings.

No point, then, in making this or that architectural design the scapegoat for what amounts to no more than one catastrophe among others, when responsibility for the event rests squarely with an unnatural practice that not only exhausts the planet's natural resources, but also exhausts the reserve of resistance of the diverse materials used, as though the (progressive) elimination of materiality had little by little become the primary objective of builders' engineers. This ultimately explains the current craze for transparency at any cost, the art of an architecture of light in which iron and glass take over from brick and stone, along with concrete, now so on the nose. This

process has even gone as far, most recently, as using techniques for suspending glass cladding that are directly inspired by aeronautical construction, to reinforce, further and further, the impression of lightness, of weightlessness, of a massive building wildly trying to be not so much real as virtual – a perfect illustration, if ever there was one, of the revival of illuminism mentioned above.

But one of the apotheoses of the progress in excess in the art of building is currently represented by a newly unveiled bridge – more exactly, a viaduct. A far cry from the 1884 wrought-iron bridge designed by Gustave Eiffel in France's Garabit Valley, Norman Foster's Millau Viaduct is a 'cult object', as the lay republican press calls it. A work of art with its deck standing nearly 300 metres above the Tarn and with a roadway 2,500 metres long, this 'static vehicle' has allowed the anticipated 25,000 motor vehicles a day over it since summer 2005.

The most revealing aspect of this gamble is the determination to be part of the tradition of the long-term commercial operation: 120 years

for the Garabit viaduct, 115 years for the same Gustave Eiffel's tower; the lifetime of the Millau Viaduct as a revenue-generator for the Eiffage Group, the company that built the viaduct and now collects the toll on it under government contract, is a mere 75 years, but the main novelty of the deal brokered is that Eiffage will turn the bridge over to the state in 120 years if the concession proves highly profitable – only, in the same condition as when it first opened...

In order to guarantee the hundred-year-plus durability of the edifice, taking into account the flexibility of the components of the 'cable-stayed bridge', 200 electronic sensors have been placed along the complete set of the viaduct's points of resistance (piers, road deck, cable stays...).

As one of the directors of Eiffage put it: 'It's rare to see a motorway project with so many instruments.'[4]

These sensors, designed to record the vibrations and pressures resulting from vehicular traffic as well as atmospheric conditions, also allow the structure's temperature to be taken. These data,

which are part of the building's health checkup, are endlessly analysed by an electronic control unit permanently installed in the viaduct's toll plaza. On top of this, eighteen video cameras automatically detect any traffic incidents and permanently alert the traffic-monitoring unit.

After the emblematic disaster that occurred in the United States in the last century when the Tacoma suspension bridge was destroyed by the resonance effect of a hurricane, the Millau work has been tested for its resistance to squalls of up to 250 kilometres an hour, translucent windbreaks three metres high allowing the impact of excessive squalls to be cut by half, it would seem, and this, 'without spoiling the bridge's transparency'.

Another record, after record altitude, the viaduct is the fastest ever built, taking only three years to be thrown up... Record altitude, record speed: if we were talking about a supersonic jet, such a performance would be easier to understand! But just listen to the architect: 'At Millau, you see the bridge particularly against the sky. We chose

light-coloured cable stays to get that transparent effect. The cables disappear and all that's left are the piers and the road deck: these seven upright needles and this thread that runs through them, it's like the viaduct dematerializes.'[5]

After the aesthetics of disappearance of cinema, the time is now upon us of the aesthetics of disappearance of real-estate 'architectonics'. But the principal challenge for Norman Foster's construction site is the use of steel for the bridge's road deck. On this score, listen to the architect when confronted by the engineers: 'While we were studying the two options of concrete and metal for the deck, we had in mind that the steel solution would produce a finer and lighter deck that would allow us to use fewer cable stays to support it.'

'Less is more', the architect Mies van der Rohe claimed – a long time ago, it is true.

After having reduced the duration of the construction site and the number of piers, it was the thickness of the deck that then had to be further reduced to nothing, that is to say, to

a thread: 4.5 metres thick for the support base, a few centimetres for the asphalt covering the roadway and a few millimetres, they say, for the steel plate of the framework!

All that just so this bridging pipeline of a structure 'pops up out of the landscape as delicate as a butterfly',[6] with a slimness that gives it such a light silhouette, a silhouette so light and so distant, so remote from the robustnesss of the Pont du Gard, so heavy, so ugly.

But this latest outlandish bout of all-out progress risks itself being overtaken by the bridge over the Straits of Messina, destined to link Sicily with Italy. A cable-stay suspension bridge, also, but one with a single span of over 3 kilometres, which Silvio Berlusconi's government was planning to open in 2006.

Over 60 metres wide, as opposed to the 32 metres of the Millau Viaduct, the road deck of this Homeric bridge – which is capable, they say, of resisting the frequent 200-kilometre-an-hour winds that blow there as well as earthquakes below 7.2 on the Richter Scale – is supposed to

comprise or carry, who knows which, 'six parallel laneways and two railway lines on a roadway all in one piece whose oscillation may, in a storm, attain six metres.'[7]

After the vogue in tunnels under the sea, even under the Atlantic Ocean, 'very big bridges' and 'very tall towers' are now all the rage...

In Asia, for example, the world's tallest building, in Taipei, is over 500 metres tall; top-level scientists have been wheeled in to assess the borderline state of the structure in question, meaning the limit beyond which the tower would suffer damage if it went any higher; the objective being to be able to calculate the safety factors that need to be built in to resist disasters and to achieve a clear 'probability of negligible ruin'. For 'negligible' read 'acceptable'.

An agreed sacrifice, as we were saying, of the progress in excess... Agreed or, perhaps, imposed by the craze in gigantism that is part and parcel of the megalomania contemporary with globalization.

In a court of last resort, who is the 'savant' who today decides what is negligible in a public catastrophe? Which court rules, in all conscience, on the scale of a predictable disaster and on those responsible for such a 'calculation of probability'?

After the event, there is certainly a judgement handed down to apportion responsibility in a calamity but, before the event, there are only research departments and design offices and the guarantee of certified expertise.

For all that, an accident is still not a 'white-collar crime', nor is responsibility the same as avowed culpability. We all know that you can't accuse the future but only the lack of mastery of a work, a work of art that is often nothing more than an extravagant trial run.

To resist or to submit to the fallout from progress? That is indeed the question posed in the age of an accelerated internationalization that no longer treats its 'advances' with any critical distance whatsoever.

Indeed, as one humorist put it, 'anyone who thinks indefinite growth is possible in a finite world is either a madman or an economist.'

To further illustrate this Babelian immoderation, if further illustration were needed, we might point to the fact that there are architecture studios currently assessing towers 800 metres high and that, in Japan, there are people already working on a project 2,000 metres high.

This is it, the art of building as far as the eye can see, where the 'never-ending tower' is never anything more than the clinical symptom of blindness.

Architecture, sculpture, painting … art is scarcely anything more now than one state of matter among others – matter that everyone is hell bent on deconstructing, dissolving or disintegrating to the point where materialism looks for all the world like nihilism. And so, after the bitter failure of the 'historical materialism' peddled by the revolutionaries of last century, the elimination of materialism itself is jinnying up as the twenty-first century gets under way.

After nuclear disintegration of the kernel of the nucleus of matter, the latest project will focus on dematerializing the science of materials, taking the notion of physical materiality towards digital abstraction.

Adopting on its own behalf, nearly a century late, the (non-figurative) approach of geometric abstraction so dear to European painters, even though its success was infinitely smaller than the success of American 'Abstract Expressionism', the electronic deconstruction under way is headed for the same dead-end where the 'illuminism of the Lumières' winds up in the obscurantism of a numerological mastery that spurns any substantial materiality as well as any distinction between the different 'realms' (mineral, plant, animal) in a fusion/confusion of forms and figures that is linked to the liquidation of representation of the world.

Gathered together on 14 February 2005 at the Royal Society of London, the world community of physicists looked at the opportunity to reinvent the kilogramme. Why the sudden concern?

'Because a natural property is invariable and can be measured at any point of the globe, whereas the kilogramme is only accessible at the International Bureau of Weights and Measures near Paris', the committee specified.[8]

What could be behind this sudden 'expatriation' of the cylinder of platinum–iridium alloy held in the pavillon de Breteuil except some new and final avatar of the dematerialization of units of measure?

A total of seven measures form the basis of an international system of weights and measures: the metre (length), the kilogramme (mass), the second (time), the ampere (electric current), the kelvin (thermodynamic temperature), the mole (quantity of matter) and the candela (quantity of light intensity). Now, only one of these measures, the kilogramme, is still calibrated using a physical object, the famous cylinder held at Sèvres, the other six now being based on unchanging natural phenomena.

For example, the standard metre of the same metal as our standard kilogramme was replaced,

in a concern for efficiency, and redefined as the distance light travels in a vacuum during one 299,792,458th of a second. As for the second, it is based on the frequency of the natural vibrations of the caesium atom. Once again, an object is replaced by a trajectory and 'metrology' all of a sudden turns into a 'dromology'!

Imperceptibly, what is wiped out here, in this 'expatriation' of standards, doubled by their 'dematerialization', is the geometry of objective forms, which yields before a trajectography in which radiations and frequencies replace the radius of the circumference, just as the speed of light of photons succeeds the rays of the sun and the shadows cast on sundial walls.

If we do not recognize here manifest proof that the aesthetics of disappearance has definitively supplanted the aesthetics of objective appearance, then blindness is at an all-time high and a panic-induced shake-up of knowledge is just around the corner, lying in wait for us!

This is it, the crisis in visual representation, in these 'primary arts' whereby exposure to

radiation deters us from tactuality and physical contact, favouring instead some kind of POST-OBJECTIVE perception or, more exactly, to risk a neologism: TRAJECTIVE perception.

It is easy to see that the geometric or lyrical abstraction of contemporary art is here out-stripped by the unexpected development of a DROMOSCOPY in which our view of the world is progressively annihilated.

But let's get back to the standardization of units of measure and, more precisely, to the new measure of the weight of the kilogramme. If the principle of the definitive abandonment of the platinum cylinder is now established, it remains to be decided what natural property will replace it. Two hypotheses stand: 'One requires us to calculate the number of atoms in an object weighing a kilogramme, which will give us a figure of around 10 to the power of 25. As for the other, it consists in calculating the electromagnetic force necessary to balance a kilogramme with earth's gravity.'[9]

Our savants are to replace, in this fashion, the scales of justice with the calculator, and

the analogy of the standard object with the digitization of an extreme precision computer calculation, the very last standard object remaining, nonetheless, the Earth and its weightiness!

'Freeing the kilogramme from the evanescence of matter in order to tie it to the laws of a nature that does not lie, science hopes to further improve the precision of electric measures'[10] – only, this time, we should note, by reference to the specific gravity of an Earth that does not move!

And so the forms of geometry are now to be seen as archaic, primitive and, why not, 'Barbaric', in a sort of metrological Darwinism in which the image of the object is to give way to a calculated trajectory more suited to preserving the measure of all things than was, once upon a time, the counterweight of the weight of the pendulum wheel.

Resistance or submission to the so-called 'liberation of the masses'? In other words, to the evanescence of the material forms the concrete object takes, number replacing mass and the weighing of those cumbersome objects in situ,

so necessarily localizable and as heavy to move around as they are, while the trajectories of whatever kind of radiation are available everywhere at once, anywhere, anytime – although not anyhow, as you need a sophisticated instrument to measure them.

'To know is to love', they say. Well, while I may know the weight in my arms of the one I love, I do not measure the electromagnetic force necessary to balance her and I do not calculate, either, the 'atomic number', or nuclear charge, of the magnetism of her body, however attractive it may be!

It is a strange numerological drift to take for a practical area of knowledge that reverts to the abstraction of a 'mathematical ideality' in which, little by little, all that is material and carnal in what surrounds us is abandoned. This distancing, this 'progressive' removal is now nothing more than a loss of vision, not so much telescopic, as yesterday, as endoscopic. And it will end, one of these days, in the profanation of the 'experimental sciences' themselves – as

we saw, looking on helplessly, last century, with the emergence of a profaned art that was a cheap substitute for the sacred art reviled by the advocates of historical materialism.

After the accident in substances, the cult of performance leads us to the accident in knowledge. Indeed, if, by definition, the materialist deconstructs the matter he is analysing to delve ever deeper into its ultimate components, this imperfect knowledge of means rather than ends will sooner or later achieve his self-destruction.

From spatial analysis to vivisection, from chemical decomposition to the splitting of the atom, the day is coming when the materialist savant no longer deconstructs but destroys, purely and simply, producing the titanic shipwreck of a knowledge once so precious. Which is what happened, in the end, on 16 July 1945, in the desert of New Mexico at the place/in the hamlet known as TRINITY SITE.

If you need convincing, just read Leo Szilard, the atomic physicist and pacifist scientist who contributed to the Manhattan Project: 'There was

then no doubt at all in my mind that the world was on the road to ruin.'[11]

Aware of the major risk of a future escalation of terror, in March 1945 Szilard even wrote a letter to President Franklin D. Roosevelt asking that the bomb be demonstrated but not used.

The American President was to disappear in April 1945, before Szilard's letter reached him, and we now know what happened after that, with this endemic proliferation that no one knows how to stop.

Drawing the logical conclusions from the historic tragedy of the militarization of science, after Hiroshima and Nagasaki, Leo Szilard quit nuclear physics and turned to theoretical biology, even declaring, apropos the atomic BIG BANG: 'That's not the kind of physics I like and I even wonder if it is physics.'[12]

Unfortunately, as the third millennium kicks off, such a heretical question no longer poses itself in relation to theoretical physics alone, but every bit as much in relation to the fledgling synthetic biology and, ultimately, to the

technosciences contemporary with the accident in Progress.

Notes

1. *Suivez l'artiste*, on Channel France 3 in February 2005.
2. Sylvie Vauclair, *La Chanson du soleil* (Paris: Albin Michel, 2002).
3. Fascist Italy, Nazi Germany and the Soviet Union. Cf. Fritz Thiede and Eugen Schmahe, *Die fliegende Nation* (Berlin: Union Deutsche Verlagsanstalt, 1933).
4. Dominique Buffier, 'Le Viaduc de Millau, l'ouvrage d'art de tous les records', in *Le monde*, 14 December 2004.
5. Interview with Norman Forster in *Le monde*, 14 December 2004.
6. Ibid.
7. Article by Marcelle Padovani in *Le nouvel observateur*, 6 January 2005.
8. Quoted in an article by Christophe Lucet in *Sud ouest dimanche*, 27 February 2005.

9. Ibid.

10. Ibid.

11. In Nicolas Witkowski, 'Léo Szilard, comment on arrête le progrès', in *Une histoire sentimentale des sciences* (Paris: Le Seuil, 2003).

12. Ibid.

3

The Night of Museums

Art is the most beautiful way for man to learn
that he has religious feelings.

Federico Fellini

'Even beyond its typically religious expressions,
true art has a close affinity with the world of faith,
so that, even in situations where culture and the
Church are far apart, art remains a kind of bridge
to religious experience ... art is by its nature a
kind of appeal to the mystery', wrote Karol
Wojtyla in his letter to artists,[1] a timely reminder
of the strict correlation between 'sacred art' and
'profane art', at the precise moment when the
paradoxical question of a 'profanation', not of
the sacred anymore, but of 'profane art' and its
free expression was about to come up.

This freedom was subject, throughout the whole of the past century, to the expressionism of terror, of its repeat atrocities, from the First World War and especially after the Second World War. Terrorized, knocked into one of the 'war wounded', art was progressively called upon to exhibit outrageous suffering and calamity, on pain of exclusion from the 'field of horror' of artistic recognition.

To violate and vilify what remained of the rules of art, to degrade the practices of profane art, as profane art previously profaned those of the various sacred arts – such was the objective of a century that was pitiless not only in relation to martyred civilian populations, but in relation to those populations' sensibilities, subject as they were to the precarious balance of a domestic terror, in which contemporary culture was soon to emerge as the simulator of the rape of the crowds.

To achieve an art foreign to art, to emancipate the visual arts, free them from what constitutes them – these are all ways of describing a

'progressive' disappearance of aesthetics, whereby the original predator, like the producer, was finally to make way for the exterminator, the one who liberates by tearing down – not just, say, the column of the Vendôme, which Courbet once tore down, but now the very bridge suspended between the profane and the sacred.

And so, after the profanation of the crowds by the propagandists of totalitarianism, it seems that the time has come for the (real) time of the profanation of their view of the world – in other words, of their spiritual orientation.

Don't forget the untimely declarations of the masters of the Stalinist era: 'Nature is not a temple but a building site.' A demolition site that especially privileges the real time of immediate history to the detriment of the real space of the temple!

Entymologically, the verb 'to profane' stems from the Latin fanum (temple) and what precedes it, pro (before), whence the term 'profane'.

With the contemporary art of disaster, we are no longer dealing with the mundane nihilism of

the monochromatic painting of an Yves Klein or the painting without images that epitomizes abstraction. This time, we are dealing with a culture without memory and without any rules whatever. This art of amnesia is part and parcel of the sudden acceleration of the real and the advent of the (polar) inertia of a world where the synchronisation of sensations freezes every representation (artistic, political,...) in a telepresence that owes everything to the transfer-machines of instantaneous communications.

A strange article appeared fairly recently in the 'art market' press in relation to a sale that went through Tajan, the Paris auction house. Headed 'The Middle Ages', this is how it ran: 'The statues of the Middle Ages have long been spurned, being considered simply as religious art.' That observation was offered by a shrewd dealer, who added: 'Medieval sculptures are wrongly seen as religious knick-knacks. The reference to the outmoded side of Catholicism has done some damage.'

Extending such typically enlightened com-
mentary, the article ploughed on: 'In Roman
art, the sculptures are fairly coarse and stylised.
We have some rather stiff, stocky pieces from
this era... For a long time likened to religious
and therefore ritual works, this statuary, though
recently released from purgatory, remains a
limited market.'

Faced with such lack of discernment (half
a century after Malraux), a person might be
forgiven for thinking they were dreaming! ...
African art, Egyptian statuary, what are they?
When amateur art-lovers collect Pre-Columbian
works of art without wondering about their ritual
significance, are they right or wrong?

But let's get back to our temple with its square
out front, before it, to a moment when Cioran
journeys back to the discovery of the little
churches of Sermaise, Etréchy, and Chamarande:
'He left me a list of these little churches and
one morning I stumbled across them,' François
George clarifies. 'They blended in so humbly with

73

the rural architecture that I could have mistaken them for God's farms.'[2] Isn't it bad faith for an atheist to admire churches?, asks the man who chose Cioran as a guide.

Certainly, there is naivety in the faith of atheism, especially when the 'lay fundamentalism' of confessors to the one true faith is so rampant, peddled by these disciples of a so-called rationalism that has remained untouched by the acceleration of reality.

Before the temple, then, there was the profane church square, the parvis, but after that, after the choir and the apse, there is nothing anymore and you suddenly run up against the EXTERNALIZATION – OUTSOURCING – OF ART.

To illustrate this disaster, you will recall that wag, the British hoaxer, who recently managed to get into four of the greatest museums in New York on the same day – the Brooklyn Museum, the Metropolitan Museum of Art, the Museum of Modern Art and the Museum of Natural History – and hang his works amidst the masterpieces of contemporary art. Some of them remained

there, exposed to public view, for several days...
Drawing the obvious lesson from his act of piracy,
the prankster, a young man named Banksy who
uses the moniker Banksymus Maximus, came
up with this: 'Obviously, museums pay more
attention to what goes out than to what comes
in.'

To thereby relativize not only the chef-d'œuvre
but the œuvre per se – this has to be the dizzy
limit in the axing of art!

But speaking of 'free entries', the operation
'Museum Night', launched in 2005 to attract a
public no longer to be seen darkening museum
doors, a Minister for Culture declared: 'This is
much more than an "open door" operation, it's
a bid to win over new audiences and create new
reflexes.'[3]

But what is going on here in such a marketing
exercise? Not being able to control the intrinsic
quality of artworks, contemporary or otherwise,
entering the collections of French museums, the
minister, anxious about the drop in attendances,
made a last ditch attempt at innovation.

After the 'Spring of Museums' in 1999, which managed to tap a million additional entries, a similar surprise attack was once more needed. Whence the 'free night-time entry' in over 700 museums in France and 400 abroad.

Outstripping the sun museum that was behind Olafur Eliasson's show, The Weather Project, at the Tate Modern London in 2003, the Night Museum was inaugurated in Paris to attract the hordes of the young and the not so young as they emerged from their night clubs; the whole thing being graced with ambient music such as in the Musée Gustave-Moreau, where evening visitors could thrill to the rhythms of Salomé's dance...

From seven o'clock at night to one in the morning, on the night of Saturday, 14 May 2005, visitors were able to venture out, feeling their way, by torchlight and candlelight, to catch a glimpse of the artworks on show – sculptures at the Musée Rodin, for example, or paintings at the Louvre, which, we are told, reached its 'saturation point' with the crowd rushing to gawp at the enigmatic Leonardo da Vinci's Mona Lisa.

In certain establishments, curators were actually called upon to act as guides to 'enlighten' viewers as to the nature of the works on show. In another example, the Musée Albert-Marzelle in Marmande put itself an hour ahead to Italian time in order to present its pictures and photographs by lantern light. A choir, also Italian, accompanied the dégustation of Venetian specialities.

'Open at Night': this announcement on the part of neighbouring businesses and drinks stalls now festoons the pediments of the temples of art, those buildings that are now being privatized at a rate of knots, once again in Italy. How long before we see cathedrals open at night so we can gawp at their stained glass windows? After the disaffection with museums, how long before we see the disaffection with places of worship that can then be turned into places of mass lay culture, ones where yesterday's 'socialist realism' will give way to the hyperrealism of an art market whose by-products will finally shunt aside works of art?

At this very beginning of the third millennium, with telescopic distancing and the remoteness of optical sensations, the TELEOBJECTIVITY of our perception of the world is doubled with a TELESUBJECTIVITY that largely falsifies our relationship with things, with their concrete presence alongside us and, therefore, with their visual representation, thereby achieving what Marcel Duchamp was after in relation to the urgency of an extra-retinal art.

This is why we better understand, today, the survival of haptic sensations – such as the success of, say, Richard Serra's sculpture, or all those famous 'installations' – in other words of all that is palpable and tangible.

But, behind the OBSCURANTISM involved in the over-exposure and inflation of instrumental imagery, how can we fail to sense the coming CRASH, a crash that will this time involve mental imagery, of an art precisely of the kind da Vinci warned us was well and truly COSA MENTALE, a mental matter?

At a time when the 'esoteric' interpretation of the Florentine's œuvre has obtained the commercial success we are all familiar with, it is impossible not to flag the scope of a disappearance that now outstrips all aesthetic discernment.

In May 2005, Scott Lash, the director of the cultural studies programme at the University of London's Goldsmith College, organized a two-day conference on the theme. The title of the conference was NEUROAESTHETICS. Olafur Eliasson, Joseph Kosuth, Brian Massumi and Marcos Novak were the leading lights taking part.

'Neuroaesthetics' is another name for a disappearance of aesthetics... Unless, this time, we are dealing with the appearance of an aesthetics of neurasthenia?

Indeed, after the mournful distancing of the objectivity de visu and in situ of domestic telescopes and the incessant overflying of the different (aero- or astro- nautical) 'atmospheric machines', this time it is the subjectivity of our

relationship to the real that beats a retreat in a panic-stricken movement that lands us in this debacle of an art outside the support-surface of our sensations.

This exotic situation was foreshadowed, it is true, by 'Impressionism' and its pictorial relativity, which kicked off the discreet discrediting of all phenomenology.

In this sense, and in this sense only, LAND ART was to have been, in the twentieth century, the key moment of contemporary art, the very last act before the artist once and for all abandoned the subject, not to go back to the studio but to enter the laboratory.

An involuntary tribute, not to the landscapes of 'classical landscape painting' anymore, but to the common ground, to its desert of terrestrial fullness, before it is totally lost to view, in this OUTLAND ART of a twenty-first century that is now just the century of the finiteness of a planet hanging in the electronic ether, frozen in the inertia of a Real Time that lords it over the extension of territories on all sides.

And so, following art for art's sake and the integral accident, is the time upon us of an art foreign to art – to the profane as much as to the sacred?

An out-of-frame, off-screen art, or more exactly, a tilt-up, in which the virtual would win out hands down against the actual in the acceleration, not of some headlong rush now, as in the days of the avant gardes but, this time, of a rush to the zenith; a fall upwards in a perspective without perspective: that of an optically correct tyranny in which the synchronisation of multiple presence (telepresence) will outstrip all representation (aesthetic or political) in a sort of sideration of sensations not unlike that produced by narcotics.

According to the Talmud, 'a man who has no ground beneath his feet is not a man'. What can you say today of this 'earthling', of this upward parachutist, in the age of deterritorialization and relocation and expatriation, also known as EXTERNALIZATION – OUTSOURCING – if not that the situation concerns each and every one of us?

HUMAN or EARTHLING? That is the question posed by an art contemporary with the end, with the finiteness of the star that saw the birth of human beings from its humus... A question addressed to art as well as to the politics of nations.

In the wake of the Soviets, who were so keen on demolition sites, here is what a Pole (Karol Wojtyla – Pope John Paul II) has to say: 'Nature is a book that man must read and not get dirty...' A German, this time, an iconic artist, has typified the status of art as a 'victim of war': Joseph Beuys.

A Luftwaffe pilot, brought down in 1943 and saved in extremis by a gang of Tartars, those territorials who allowed the man to survive in aeronautical weightlessness, the flying artist was not identified as such, but simply as an enemy to be saved in spite of everything. As you will note, yet again, when it comes to the twentieth century, it is impossible to talk about art without talking about flight, ascent – from Beuys to Turrell via a whole host of other artists.

An inveterate theorist of the 'broader concept of art', the aviator who metamorphosed into an avant-garde artist illustrates to perfection the 'obesity' or, more precisely, the dromospheric expansion of Western culture after the total war and its aerial atrocities.

But, note once again, if the landscape painting of the Classical age gave rise, with 'seascapes', to the hydrospheric landscapes that were to inspire nascent Impressionism, the atmospheric landscape of clouds that the art of flying revealed has scarcely left a trace on the history of art, despite the Futurists' attempts at aerialization. After Tatlin, we had to wait till the twentieth century reached the halfway mark before we saw the sphere of influence of an art without gravity expand with Pollock... This dromosphere of an acceleration of reality that would lose sight of the point and the line as well as the surface of the ground, despite the return to the desert of the American LAND ARTISTS.

But in terms of a 'broader concept of art' as championed by our bomber pilot, Beuys, we

had to wait further still for the expansion of mass culture to finally see the advent, after the megalomania of total art and the blindness of extra-retinal art, of the megaloscopy of 'art as far as the eye can see' that was to lead to the distancing of immediate sensations and end, finally, in a teleobjectivity more populist than popular, within the very latest COMMUNISM, where the old community of interest gives way to an instantaneous community of emotion, and where 'mass individualism' takes over in turn from the collectivism of totalitarian regimes.

And so, after the œuvre sans figure and the painting sans image, the time had come for the artist sans œuvre, 'conceptual art' leading, after abstraction, to abstention pure and simple; the blank vote of the monochromatism of an Yves Klein yielding its pictorial parody to the theatrical 'living spectacle' of an author without any authority whatever, except that of exposing himself to the eyes of all, of exhibiting his name or his initials (just like a logo). This is a subliminal form of self-portrait, in which obscenity no

longer solely involves sexual or scatalogical exposure but is practised on the profane avant-scene, front of stage, that proscenium where the narrator moves forward to meet the audience and alert them as to what is happening on stage, thereby denouncing its 'sacred' dimension.

Notice how, here, the desertion of the producer deprived of an œuvre is accompanied by the title role of 'public informer', of denouncer of what ought to be condemned without any possible protest, on pain of alienating the free expression of the 'presenter', that anchor of disapproval of the sacred as of the profane...

Here we see, once more, all the outrageous excesses of the tribune, transferred to the realm of the visual arts as well as to the realm of the arts of the stage. Whence the success of the street arts of so-called urban culture. But there remains the dread of a forced acquiescence, under threat of expulsion, not of the œuvre, now, as in the age of the auto-da-fé, but of its spectator, deprived not only of an authentic representation (theatrical, pictorial...) but of his or her free will;

the appreciation or depreciation involved in the old Quarrel of the Ancients and the Moderns now giving way to the obligation of a duty of confidentiality before the freeing up of the rules of art.

The faith of sacred art and the talent of profane art are then overtaken by the categorical imperative of a 'mentor' freed from the weight of the manifest artwork, but having in hand the 'Tables of the Law' of a freedom of expression sans free refereeing, in which that other quarrel, the one between the iconophiles and the iconophobes, in turn disappears before the abstention of the conceptual artist. This is a veritable Kafka trial in which the art lover is now a mere accomplice obligé, the 'stooge' in a charlatanism that no longer even speaks its name.

But let's go back to this communism of public emotion that has recently, so discreetly, replaced the communism of public interest.

Launched at the beginning of the twenty-first century, the Corporate Storytelling of the Anglo-Saxon world aims at reorganizing history and

its tales in politically correct fashion, in order to shape social behaviours – along the lines of the new management, with its spin doctor magician, the accredited astrologer of the business of globalization of public emotion indispensable to the single market. This customized, 'results-oriented' communications 'system' now replaces, in so doing, the 'International Proletariat' of the ex-Soviet Empire, using a welter of media conditioning techniques borrowed from contemporary culture to promote opinion transfers in a pseudo-democratization of emotion that has taken over from the democratization of public opinion that was once the province of the representative assemblies of yore.

And we won't understand anything about the crisis the European Union is undergoing or the refutation of the Judeo-Christian origins of the Old Continent's history unless we come to grips with this hijacking worthy of storytelling that so many lay intellectuals collude in – while so rightly assigning themselves the task of denouncing negationism...

In 1932, in a letter addressed to Albert Einstein, Sigmund Freud recognized that, since time immemorial, humanity has been subject to cultural evolution and that we owe the best of ourselves to this phenomenon – as well as a large part of what we suffer. 'The psychic transformations that accompany the phenomenon of culture', he wrote, 'are obvious and indubitable... Sensations which, for our ancestors, were charged with pleasure, have become indifferent to us and even intolerable.'[4]

It is in this perspective that we might consider, today, the damage done to an art that is a victim of total war and that is gearing up to suffer the disaster of mass telesubjectivity that some people present as the height of social communication.

Concluding his letter to the man who was shortly to contribute to the launch of the Manhattan Project, Freud warned: 'It does seem that the aesthetic degradations that war entails count no less in our outrage than the atrocities war gives rise to.'

German Expressionism, Dadaism, Surrealism, Viennese Actionism are all so many confirmations of Freud's analysis. He concludes: 'We are not yet familiar with the idea that cultural evolution might be an organic phenomenon, of the same order as the domestication of certain animal species.'

Since those days, after the camps, and, more recently, after the information revolution, this familiarity with the domestication of the public has become patently obvious – to the point where the phenomenology of perception DE VISU is reversed, thanks to the teleobjectivity of a view of the world that has taken us from the collectivism of bygone days to mass individualism.

In fact, and as we pointed out earlier, our contemporaries no longer want to see but only to be seen by all the tools of audiovisual televoyance.

This is it, the reversal of the scopic impulse of voyeurism, along with the boom in transfiguration, a lay version, now, but one that owes everything to the illuminism of the real time of an instantaneity likely to inspire, tomorrow or

the day after, the revelation of a myth of trans-appearance in which exhibitionism will achieve its goal, promoting not only the synchronization of sensations but, especially, the globalization of affects.

A perverse situation in which the 'communism of public emotion' will be redefined à la Lenin: 'Revolution is communism plus electricity.' To adapt this to current tastes, all we have to do is replace 'electricity' with 'electronics'.

Strangely, and as though to confirm this transfer of the voyeur to the congenitally blind, of which Ray Charles was a sublime example, after the sunglasses and the balaclavas and the hoods, we are seeing today the burying of ocular perception behind pseudo-masks.

As further proof of this observation, we are also seeing linguistic violence and even crimes committed as payback for 'dirty looks'. This has reached the point where, in certain residential estates, some people, and not only young women, walk with their eyes riveted to the ground in order to avoid any aggression.

At a time when walls are everywhere and bor-
ders nowhere, this fencing-in not only contributes
to erecting tomorrow's CLAUSTROPOLIS. It
especially contributes to suppressing perception
of our surroundings, because faces are not the
only things veiled now, as a short while ago. The
visual field, too, is shrinking badly, illustrating
by this fact the topological or, more accurately,
TOPOSCOPIC about-face evoked above, for,
instead of projecting ourselves into the distance
and all around us, we keep our eyes down to
look only at our toes in what is not even timidity
any more but a form of introversion. In this
forced perspective, our vision of our immediate
environment is no longer anything more than
guilty introspection, capable tomorrow of ending
in a public confession, at the express behest not
of some political commissioner any more, but of
the public presenter, the disc-jockey of 'urban'
culture...

Significantly, what we are seeing in 'musical
pop culture' circles, following deployment of
the hood, is the use of various masks by singers

and musicians in bands performing live on stage.

Once there was the balaclava of the kamikaze, then there was the more-or-less monstrous mask or, going even further, the video headset of virtual reality. Now, what is emerging with the barricading of the artist behind his instruments is his pure and simple blindness.[5]

One such musician puts it in these terms: 'On stage, make-up helps us focus exclusively on the music, on getting out of ourselves.' In other words, on getting into ex-tacy. Here the mask is no longer a carnival disguise, but 'a safety-valve behind which you can do violence and do violence to yourself'.[6]

All is said, nothing is seen, since the mask rules out all identification and puts paid to the notions of authenticity and embodiment that still characterized the rock era.

Robot mask or death's head, it is no longer work that makes you free here, it is anonymity that promotes licence. From now on, contrary to what Paul Klee claimed, art no longer makes

visible but blinds. As for the mass culture of the century of audiovisual illuminism, it makes you deaf and dumb in the face of any heretical opposition to its conformism.

Let's now go back to the TOPOSCOPIC reversal stemming from the acceleration of the real, as the third millennium gets under way, with an endless round of satellites observing and monitoring, point by point, the surface area of a globe where earthlings have come to no longer look at anything, beyond their screens, but the ground, the surface that supports them.

Dispossessed of the horizon, of its line and its vanishing point, the erstwhile observer suddenly turns their ocular perception inward and limits their gaze to the 'support-surface' of ordinary everyday territory, even while their long-distance vision is transferred, no longer to the antique field-glass, but to the innumerable television channels and sundry WEBCAMS that illuminate their abode more intensely than electric lighting can possibly do.

Very recently, home delivery of blockbuster images designed to appeal to a wide audience has been paired with the televisiophony by means of which the insupportable portable, in tandem with voice mail, allows you to see and especially to be seen by your interlocutor. This third-generation mobile telephone still further distracts the attention of those circulating, at the risk of causing the kind of accidents that result not so much from loss of control of a vehicle as from the driver's inattention.

In Frankfurt, certain cinemas have recently found a remedy for employees' stress: they offer cinema sessions SANS FILM, so that everyone can relax before getting back to work. At 3 euros for a thirty minute session and with soft background music, the concept is all the rage throughout Germany, with ninety cinemas already offering the service.

After Guy Debord's film sans image of 1952, this new 'service' means attacking the author of The Society of the Spectacle from the rear since, if we follow this concept in vogue on the other

side of the Rhine (and the other side of film) to its logical conclusion, the general strike could soon become the very latest public service...

Here again, procedural inversion, toposcopic reversal of the situation, the turnaround distinguish themselves by withholding, by lack. Alongside the sunglasses and hoods in vogue in the suburbs, the darkroom is now actually reviving, for a harassed collectivity, the balaclava of idle individuality.

Not only do you no longer look up at the firmament to gaze at the stars. You no longer even look at the screen. The latest screening is a doze, a siesta, in a room SANS SPECTACLE, which would be to the 'public transport' that films are what the waiting room already was to the railway station in the days of the Lumière Brothers...

After the strike by people employed intermittently in the performing arts, we now have the intermittence of movie theatres, freshly morphed into 'altars of repose' of unemployment, or, more aptly, day centres taking in the vagrants of idleness...

But that's enough of these out-of-date considerations. Let's get back to the toposcopic reversal that characterizes the twenty-first century. Following the telescopic hijacking of astronomy, along with domestic television, we are thus seeing the beginnings of another hijacking, this one 'endoscopic', revealing the closing in of the terrestrial globe, where the ultimate vanishing point is now to be the centre of the Earth: this kernel where the real space of geopolitical extension has just ended (or more exactly crashed), literally becoming confused with the centre of time, of this real time without localization other than the axis of gravity that still resists the chronopolitical instantaneity of the globalization under way, in a TEMPORAL COMPRESSION with more serious consequences for human beings than those resulting from the shifting tectonic plates of our tiny telluric planet.

In fact, what is profaned with this reversal of perspective is the concrete orientation of our 'view of the world'; of a world once panoramic,

open to the infinitely big, which, thanks to acceleration of reality, suddenly becomes the hypercentre of interactivity, to the detriment of a universal exteriority delivered up to the lack of localization, to the loss of any true position (ethical, political...), where the thin habitable film of geophysical expanse is internalized, literally locked up at the centre of the 'world time' of immediacy and its panoptical ubiquity.

This is it, this about-face, not so much topological as toposcopical, this absolute here of carceral entropathy, this zero degree of the freedom of movement of a world that has turned INFRAMUNDANE.

It is right here, the hidden problem of the pollution of distances that finishes off the pollution of substances belonging to the old ecology, this 'integral accident' of the profanation not only of nature but of its size, its LIFE-SIZE GRANDEUR.

On this point, let's hear it from Edmund Husserl once more:

We also need to study the relationship between optical space and haptic space, the extent to which a grounded corporeity necessarily constitutes itself in optical space, on the one hand, and, on the other, in haptic space; and finally, the extent to which it necessarily constitutes itself according to the proper meaning of corporeity and by asking ourselves further what is the place of the necessary constitution of the flesh? Terrestrial ground, walking, resistance, praxis, collision and production of effects at a distance.[7]

How can we inhabit a nature now without grandeur? How situate one's body of flesh, one's language and one's art, in a voyage to the centre of the Earth that owes nothing to Jules Verne, for it does not require any physical displacement (subterranean or otherwise), nor any voyage in space, this CENTRE never being anything other than the centre of time, of the 'real time' of a depth without density?

In the standstill of this meta-geophysical on-the-spot motion, and thanks to the egocentricity

of the living-present studied by Husserl at the end of his life: *the centre of the Earth is me!* Nothing but me, and no longer us, mass individualism never being anything but the (forbidden) fruit of a finite world revolving around the egotism of the 'living-present' of each and every one of us. This present directly (live, life,...) reflects the real time of a media-generated immediacy that takes over, by deception, from the only-too-real space of bodies and their age-old freedom of movement in the geophysical expanse of a human habitat now returned to its original inertia.

By way of confirmation of this hypercentration of contemporary individualism, let's now look at the supposedly eccentric lifestyles of those who can do anything, or very nearly.

Leaving behind Bill Gates and his dwelling of over 6,000 square metres, from where the Corbis magnate can call up, at every instant, displays of the works of the museums of the entire world on the multiple screens that decorate the walls of his rooms, let's now contemplate the villa of

the actor, John Travolta. This villa is situated at the centre of a private airport that has two landing strips and overhead walkways providing a direct link between the building's living rooms (on the hiking tour) and the cabins of Travolta's Boeing 737, stage right overlooking the garden and his business jet, stage left, the two vehicles, big and small, of the ambulatory dwelling that each comprise the 'spare parts', no longer of a dwelling in which to stay, but of a sort of 'control tower' from which to leave, to exit – exclusively upwards, not at ground level, the garages being nothing more now than sheds storing collector cars.

A name springs to mind for this type of twentieth-century 'folly' that replaces the old home-sweet-home: an EXIT-HOUSE. For in it the place of ejection takes over from the places of predilection of the communal city.

Between the teleobjectivity of the man who transforms his dwelling into a VIDEO POST-PRODUCTION UNIT and the aeromobility of this master of the house cum captain of an ambulatory

residence, MEGALOSCOPY has reached an all-time high. Alongside the multiple screens of the control room that display images of the world – what no one dares yet call his 'instrument panel' – as on board this control tower for private jets, each man is not only on the edge of the terrestrial globe but at its brink, in this delirium that Howard Hughes prefigured before winding up bedridden at the top of the tower of the Desert Inn in Las Vegas and then dying in flight, on board a flying doctor aeroplane.

Strangely, too, a connection can be made between these exercises in an ambulatory madness (dromomania) and those of the relocation involved in political or security internments – that diaspora of the American concentration camps.

In fact, following the outsourcing of torture chambers to the four corners of the globe, we now have the exotic relocation of an abomination, this one furtive, since it seems the legal system can't detect it, for it not only sets itself up above the law (as the president of the Red Cross cautioned)

but above the ground, in weightless suspension in 'secret planes' chartered by the CIA, such as the Boeing 737 and the Gulf Stream Turbot used for transferring detainees suspected of terrorism and held illegally.

In response to these unpleasant practices, listen to St Augustine: 'The mistake the soul makes about itself stems from identifying with such images so lovingly and intimately that it ends up judging itself as some like thing. It becomes absorbed in such images, not through this being but through thinking it is: it is not that it imagines itself to be an image, but it imagines itself to be that which it carries the image of inside itself. For the power to judge subsists in the soul and causes it to distinguish the body that remains external to it from the image that it carries inside it – unless these images are externalized to the point of being taken for the sensations of foreign bodies rather than internal representations. This regularly happens in sleep, in madness or in certain trances.'[8]

But, speaking of transport, of transport to the brain, the final stage of such madness is today achieved by the ultimate pantheist idolatry: identification of the human being's body proper with the earthling's world proper.

In this individualist delirium, I am the whole world, I am the one who is, the one who was, and the one who will be! A fatal demiurgic conclusion whereby humanity, totally confused with the humus of our origins, no longer even distinguishes the expanse of the geophysical environment from its own physiology, in a sort of cult of personality that strikes, this time, not only the tyrant, but the common run of mortals – in other words: each and every one of us.

In a documentary essay on 'superstition', Serge Margel signals the surge not only in sectarian, esoteric and related practices but in the individual religions to come, that will emerge from the ruins of symbolic power: 'As soon as society is limited in its symbolic power, superstition becomes inevitable and, therefore, necessary

as a compensation for the disequilibrium that constitutes it ... and this is when civil lay society will find this specific type of equilibrium in personal religions that the individual establishes by himself and for himself.'

Pursuing this report of the bankruptcy of the political that betrays the body-proper's practices of INTROPATHIC fusion with the world-proper of physical finiteness, the author writes:

> To rethink here the individual, the unique, the singular, above and beyond any opposition between 'individualism' and 'collectivism', means reconsidering the individual in their limit or limited state. No longer at the limit but as themselves limit of the impossible symbolic representation of society. And so, as limit of society and nation – but also of generation, tradition, soil and blood.

Margel concludes: 'The individual here is the setting up of the landless, meaning not only those who no longer have any land, but the one

who will never again have land, never again have flesh and blood, their own flesh and blood. Individual religions on the outer edges of the Earth.'⁹

Curiously, this terminal approach to beliefs and creeds makes no reference to megalomania, to the disaster that has befallen the political assembly and the ecclesia. But, conversely, it introduces the catastrophic possibility of a new form of 'civil war', which would no longer be the not-so-distant war of each against all, but the suicidal war of each against each. Let's go to the very last lines of Serge Margel's book:

A new temple for a new world. New conflicts, too, new outbreaks of violence and new forms of tolerance which we will have to think differently. What also looms in the appeal of new religions is a war of the landless for a world to come, based on 'better promises'. In brief, new wars of religion are gearing up... This will no longer mean war between institutions or on behalf of an institution. It will mean religion sets itself up as war.¹⁰

105

What Margel is describing, in a way, is the civil war of a MONOTHEISM in which 'the unique and its property' take themselves for the completely other, all on their own!

Megalomania or megaloscopy? We can well imagine that this fanatical demiurgy of mass individualism conditions not only the political event of atheism, but the whole of culture – that 'view of the world' that is inseparable from the issue of God and thus of all religiosity, individual or collective.

The quarrel over images of the iconoclasts then turns into a quarrel over the VISIBLE and the INVISIBLE; a quarrel not only about the OBJECT, pictorial or otherwise, and the SUBJECT, but about the TRAJECTORY without delay that goes so far as erasing the very memory of the 'mental map', the mental mapping that once allowed us still to get our bearings, to stand up to the other as well as the completely other.

Strangely, when it comes to superstition and magic, Margel's essay doesn't tackle multimedia power and its teleobjective creed, or social

conditioning and its interactive feats, or the emotional synchronization that results from it today – on a planet-spanning scale.

All the same, all the same, how can we treat superstition seriously without tackling the emergence of public opinion?

Even if the word 'public' makes reference to the res publica and even if private faith relates to the ecclesia, public opinion is no more foreign to faith and beliefs in a radiant future than emotion is to reason.

Also, apropos the visibility now at issue in the religious as well as the political order, let's not forget that the sight of a path, the line of sight, that allows man to attain his target, used to go by the name, in French at least, of 'line of faith', only yesterday, though the term is today censured and replaced by the term 'line of aim'...

Superstition or religion? Objectivity or subjectivity? TELEOBJECTIVITY of communications tools or TELESUBJECTIVITY of the audiovisual?

So many questions contemporary with a cultural malaise that does not date from the

twentieth century, whatever they say, but from
the Age of Enlightenment. But this malaise finds
itself singularly exacerbated in the twenty-first
century by the emergence, fatal for representative
democracy, of this ILLUMINISM of the Last Day
that goes by the borrowed name of – real-time
– INFORMATION REVOLUTION.

Whether we are dealing with the objectivity of
reason or the subjectivity of belief, we will never
make head nor tail of this particular revolution
without according, at last, the place it deserves
to the trajectivity of the waves that carry the
messages of the medium; those electromagnetic
vibrations that tug at the heartstrings and in-
sidiously collectivize emotions that owe every-
thing to the immediacy and the ubiquity of
information flows that cross the virtual space of
telecommunications – in 'real time'.

In an important course given at the Collège de
France and devoted to the internationalization of
law in the age of the necessary governance of the
Internet, Mireille Delmas-Marty remarked: 'How
can we apply this requirement to digital networks

devoid of any management centre and that are NEITHER OBJECTS NOR SUBJECTS OF LAW, but conceived in some sort as A PATH, a trajectory passing first through the access provider, then the host, then the content editor and, finally, the internet user?'[11]

She concluded: 'From financial flows to information flows, the issue is not deregulation, but the appearance of a space that cannot be assimilated into a territory (and so is, in this sense, virtual), that is neither private nor public but simply outside the law.'[12]

This is it, the profanation of 'the art of the possible' of the politics of nations; this is definitely it, this OUTLAND ART that denies representative democracy its inscription in the real space of some soil, and thus its territorial localization; real-time exchange flows further accentuating the difficulty of framing, legally or otherwise, a transnational activity now corrupted into a sort of (virtual) interactivity that dissolves, one after the other, the spaces of the law as surely as nuclear radiation dissolves those of the body.

109

By way of conclusion, one question has to be asked: in the wake of the popular democracies formed by totalitarianism's community of interest in Eastern and Asian countries: is the direct democracy of the global age's community of emotion still 'democratic'?

Or is it not, rather, a sort of COMMUNISM of public emotion that cunningly revives that of Marxism, in order to serve the interests of a TURBO-CAPITALISM of real-time exchanges, in a world from now on devoid of the limits and time lags that the geopolitics of nations was still, only yesterday, based on?

Whereas the old community of interests of collectivism was based, for its part, on the ideals of social justice (diverted away from Christianity), the community of emotion of mass individualism is built on the management of fear, of precariousness, thanks to the prowess as well as the promise of immediacy and ubiquity.

In plain language: can democracy be TOTAL and interactive without immediately ceasing to be democratic and truly participatory? This

all boils down to asking, though the other way round, the question of the necessary separation of church and state on which republican secularism is based. Can democracy be universal, in other words catholic and cathodic, without being something other than a glitch, the integral accident in politics?

This is surely the reason for today's boom in the transpolitical vulgate peddled by liberalism and, especially, by the ideology of a sovereign interactivity that will end, tomorrow or the day after if we are not careful – just as the interactivity of radioactivity did yesterday – in the overriding necessity for a new kind of DETERRENCE, one no longer military but civil.

This is surely also the reason for this threat of the disappearance of the legitimate state, 'these risks that bring us back to earth, from virtual space to real space, but that apparently distance us from the field of law, for what characterizes them is uncertainty. However, to take uncertainty into account should not lead us to base on fear an ethics that would then wind up blocking

111

scientific research as well as political decision-making', Mireille Delmas-Marty goes on to write, adding: 'This is how globalization prompts a worldwide policy of prevention and precaution, whether concerning biotechnological or ecological risks.'[13]

We might add the risks of terrorism to the list and thus infer the need for a strategy of preventive war, such as the Anglo-Americans have led in Iraq, with the success we are familiar with...

Taking the uncertainty principle into account in the politics of globalization actually contributes to the introduction, everywhere at once, of preventive action and anticipation of threats, including those that now weigh on representative democracy. And, here, the accident or, more exactly, the catastrophe of contemporary art is prophetic of the major risk of public profanation that now threatens all REPRESENTATION and, in the short term, all 'civilization'.

Before the visible, there is the profane nature of the pre-visible, but, after the visible, all that

subsists is the imprévisible – the unpredictable, the unexpected – along with the revelation of the accident in knowledge.

Notes

1. *Letter of His Holiness John Paul II to Artists* (Libreria Editrice Vaticana, 1999).
2. François Georges Mathurin Maugarlonne, *A la recontre des disparus* (Paris: Grasset, 2004).
3. Agence France Presse correspondent in *Le Monde*, May 2005 and *Sud ouest*, 12 May 2005.
4. Albert Einstein, Sigmund Freud, *Pourquoi la guerre?* (Paris: Rivages, 2005).
5. 'Chanteurs masqués' in *Chronic'Art*, No. 19, April-May 2005.
6. Ibid.
7. Husserl, op. cit.
8. St Augustine, 'De Trinitate', Book X, Chapter VI: quoted in Serge Margel, *Superstition. L'anthropologie du religieux en terre de chrétienté* (Paris: Galilée, 2005).

9. Margel, ibid.
10. Ibid.
11. Mireille Delmas-Marty, 'Le relatif et l'universel', course and course-work for the Collège de France, published in the college yearbook, 104th year, 2003/4.
12. Ibid.
13. Ibid.

4

Art as Far as the Eye Can See

Is an art that endlessly solicits cognitive persistence visual or musical? Is an art that no longer addresses itself so much to the visible as to the audiovisible a graphic art? So many questions that today are without answers, yet determine art criticism.

The moment the whole array of the visual arts is suddenly overexposed to mass communications tools, the question of retinal persistence poses itself in a completely new way, one that puts paid to the now sterile criticism of, say, Marcel Duchamp denouncing the limits of retinal art. While certain filmmakers – like Pip Chodorov – try 'to make the visual cortex undergo what music does to the temporal lobe'[1] and cinematographic

imagery becomes, in a way, the backing for music, this is not so much about music turning into IMAGE as about image turning into MUSIC – graphic, photographic image, certainly, but also, equally, the digital array of computer imagery that now tends to supplant the analogic regime of optical imagery.

Wherever the instrumental image of the audiovisible replaces the mental image of the visible, in fact, what comes into play is the coup de force of a so-called TOTAL ART in which the seventh art of cinema, not content to contain all the rest, as Georges Méliès hoped, suddenly opts for a fusion/confusion of genres in an ICODIVERSITY of the perceptible which is the equivalent of the BIODIVERSITY of species, to end in the unicity of a sensation that some people like to think of as a 'visual orgasm',[2] whereas it is actually nothing more than a fatal amputation, the castration of the difference between the five senses that enables us to experience the relief of bodies and their distinct shapes, along with the world's relief.

116

Photography has never actually been anything more than the first of these 'arts of light' that have little by little contaminated the perceptible through a 'photosensitivity' whose history is yet to be written.

Even though, from the very beginning of photography, the heliographic shot put TIME-LIGHT to work – that is, the limit speed of a luminous radiance – the graphic arts, for their part, enlisted the TIME-MATTER of the sole persistence of a material support (canvas, stone, bronze,...) and, thereby, the aesthetics of the progressive appearance of the figures of the visible.

With the photogram, this resistance of materials came to an end, leaving room only for the cognitive persistence – accordingly known as 'retinal' – that allows for perception of movement and its acceleration, from the cinematograph right up to the recent feats of real-time audiovisual videoscopy. Whence the term art-light for all that now enlists in the aesthetics of disappearance, whether filmic, analogical or digital.

And so, with the audiovisible and especially
the turning into music of the image, of all
images, sonorous and visual sensations, far
from completing each other, are confused in
a sort of MAGMA where rhythms hold sway
over forms and their limits, swept away as they
are in the illusionism of an ART WITHOUT
END, without head or tail, where you literally
no longer distinguish anything apart from the
rhythmological rapture. There is no clever feat
of deconstruction here, only the beginnings
of pure and simple dematerialization of the art
of seeing and of knowing; the confusion of the
perceptible that is analogous, in many respects,
with the confusion of this Babelian language
where everything dissolves into the indistinction,
followed shortly by the indifference, then by the
passivity, of a befuddled subject.

An obvious point imposes itself here: if seeing
and knowing were, until now, the great quests,
at once ethical and aesthetic, ever since the
eighteenth century with its Enlightenment, seeing
and being able have become the great quests of

our twenty-first century, with the outstripping of the politically correct by the optically correct – this correction that is no longer the ocular correction of the glass lenses in our spectacles but the societal correction of our view of the world, in the age of planetary globalization.

In effect, if totalitarian societies tried to realize such a panoptic policy, the global society that is looming possesses the audiovisual tools to bring it off completely, thanks to the acceleration of reality of which the art of seeing is perhaps the very first victim.

Here, the issue is thereby no longer only to do with the 'figurative' and the 'non-figurative', as in the twentieth century, but indeed concerns representation in the real space of the artwork and the pure and simple presentation, in real time, of untimely and simultaneous events or accidents that certain artists sometimes call performances or installations...

Even while the acceleration of art history, at the beginning of the twentieth century, merely prefaced the imminent ousting of the figure,

meaning of all figuration, the acceleration of reality contemporary with our twenty-first century once more undermines all 'representation', not only pictorial or architectural but especially theatrical, to the detriment of the political stage of representative democracy.

Whether we like it or not, what is today very largely contested by the outrageous excesses of cybernetic progress, as well as of hypersonic acceleration, is the whole set of representations. What are exclusively promoted thereby are these techniques of instantaneous telecommunication of real-time presentation of facts as well as of artworks that were once visual and are now purely 'mediatic'.

All that is still fixed is in fact threatened by this 'panoptic inertia' of the speed of light in a vacuum; of these electromagnetic waves that dematerialize the œuvre using the optical radiance of daylight – exclusively promoting the electro-optical radiance of the false day of screens.

HERE, but where is that, in the end? The graphic sedentariness of the visual arts becomes

a defect in the face of the general mobilization of sequences no longer animated as yesterday with the film reel but infinitely accelerated right to the limit of visibility of images (analogue, digital, ...). And this has reached the point where morphing now outstrips the ancient immemorial morphology of the figures of representation.

In an age when our view of the world has become not so much objective as teleobjective, how can we persist in being? How can we effectively resist the sudden dematerialization of a world where everything is seen, déja vu – already seen – and instantly forgotten?

How can we persist in the real space of the œuvre, while the acceleration of real time sweeps away everything in its path?

On this score, here is Maurice Blanchot: 'Talking and writing are not the same as seeing. Whence my apprehension when I see the written word move to the visible. Even reading out loud is painful to me.'[3]

While retinal persistence furnishes the background necessary to all perception of movement,

the same cannot be said for the cognitive persistence of speech and its fleetingness. Whence this unbearable forgetting, when faced with the audiovisual scene of the mass media.

As a man of the theatre explains in relation to a representation where the voice of the actors is given to the variations in stage lighting: 'In times of over-communication, the value of the word is lost.'[4]

Of the word, certainly ... but what about of art, of its traces as rock painting in this art of design that is inseparable from the designs of the author?

If over-communication is fatal to the dramatic stage, over-exposure is equally fatal to the artistic stage, to its authenticity in a panic-ridden world where the nebula of contemporary art never ceases growing, like the fog of war; this 'war of images' that will from now on be delivered to us in closed circuit – until the revolving PANORAMA offers us, tomorrow, in real time, if not the end of the world then at least the end of 'the art of seeing'.

'Maybe she died from never having been seen?', wrote Guy Dupré, in 1962, of the death of French novelist, Roger Nimier's girlfriend, who disappeared one night in a car accident that cost both her and Nimier their lives on the highway west of Paris.

Before such nebulosity, in which the violence of colliding images seems the only means of expression, the objective œuvre, for want of some chef d'œuvre, emerges like a phenomenon of resistance.

Through its visual affirmation, in the face of the avalanche of information, it reinstalls the emergency ramp without which no culture is likely to 'last'.

Art-Light in the process of turning into the music of the televised image, or else art-matter of the visual arts – we have to choose. We have to choose between dynamics and its panic, the putting into a trance of the enthralled multitudes, or statics, material resistance and its tectonics of sense as well as shared sensations. It is here, I think, that the fate of political philosophy is today being played out.

Even while the 'nationalism' of days gone by was centripetal, exerting a gravitational pull towards the centre, into its capital, on power and rural populations, the transnationalism of globalization is, for its part, centrifugal, ejecting outwards towards the outside all that was still precisely located, here or there.

And so, the globalization under way acts in the manner of a CENTRIFUGE that outsources any and every (geophysical) implantation and any and every (geopolitical) representation. EXTRA OMNES (everyone out) could well be the slogan of this DROMOSPHERE of the acceleration of reality, where the centre is nowhere and the circumference everywhere at once!

In a prose piece dating from the year 2001, Louis-René des Forêts wrote: 'Thought gravitates around the same haunting theme with so little variation that you would swear it was enthralled by this orbital movement, bewitched by it. Yet it nevertheless persists in the hope that its capacity to break out of the circle and take off will be restored to it ... the optical error to be avoided

being to throw what derives from life at what is its absolute negation – in anticipation of this happening.'[5]

But let's get back to our centrifuge, so useful in training the astronaut to leave the ground. By dint of copping the 'Gs' of the merry-go-round's acceleration, the fatal moment comes when that human guinea pig suffers what is known as a 'blackout' in which he loses sight and faints...

That is where we are at, or almost, in the realm of the culture of sensations. The main sign of this is the extreme infatuation with music to the detriment of the plastic arts, producing this *Stimmungsdemokratie* – democracy of mood – which is taking over currently from the democracy of opinion, where reflection in common once claimed to hold sway over the conditioned reflex.

The very first politics of speed is the art of music, this 'art of the fugue' in which the present, the present instant, dominates tempo and musical rhythms.

So it is only logical that the long duration of contemplation de visu – with our own eyes – is being annihilated, the putting of silence on trial through works exposed to the eyes of all, promoting the emotion of each, at the same moment.

Today, the economy of culture has radically changed nature, since the principle of accumulating major works has been overtaken by the principle of accelerating the display, the turnover of an art in permanent transit.

As for the museum that, nonetheless, constituted the public treasure belonging to the generations to come – it is literally pillaged by the advocates of an audiovisual administration in which the music of the spheres sweeps away, one by one, the voices of silence, just as the voices of the sirens once sent ships and their cargoes to the bottom.

Notes

1. Pip Chodorov, quoted by Jennifer Verraes in the revue, *Trafic*, Spring 2004.

126

2. Chodorov, ibid.
3. Maurice Blanchot, 'Lettre à un jeune cinéaste', 16 August 1986, quoted in *Trafic*, No. 49, Spring 2004.
4. Joël Pommerat on the subject of his play, *Au monde*, a show about speech. Extract from an interview with J.-L. Perrier, in *Le monde*, 9 March 2004.
5. Louis-René des Forêts, *Pas à pas jusqu'au dernier* (Paris: Mercure de France, 2001).